THE FBI FILES

ARNOLD MESCHES

Hanging Loose Press
Brooklyn, New York

Published by Hanging Loose Press, 231 Wyckoff Street, Brooklyn, NY 11217-2208. All rights reserved. No part of this book may be reproduced without the publisher's written permission, except for brief quotations in reviews.

www.hangingloosepress.com

Printed in the United States of America
10 9 8 7 6 5 4 3 2 1

Hanging Loose Press thanks Steven Schrader for his generous contribution and the Literature Program of the New York State Council on the Arts for a grant in support of the publication of this book.

The artist is most grateful to John McCall and the Pollock-Krasner Foundation for their extraordinary generosity and support. The artist also wishes to thank Robert Storr and Daniel Marzona for their friendship and assistance, Alanna Heiss and the wonderful staff at PS 1 Contemporary Art Center Museum of Modern Art Affiliate, Robin Tewes and Hanging Loose Press.

Cover art and design by Arnold Mesches

Library of Congress Cataloging-in-Publication Data available on request.

ISBN 1-931236-41-0 paperback

For Jill,
And, for my children, Paul and Susan
And, for my grandchildren, Tai and Kim

Produced at The Print Center, Inc. 225 Varick St., New York, NY 10014, a non-profit facility for literary and arts-related publications. (212) 206-8465

THE FBI FILES

The FBI started shadowing me as early as October 5,1945. They stopped writing about me, according to the file pages I just received through the Freedom of Information Act, somewhere in early 1972. The usual variety of cropped hair, suit and tie shadowers, the cliched kind seen on TV, were called "Special Agents (SA)." They'd phone, on the pretext of selling car insurance, or, pretending to be the "subject's friend and customer," (6-5-53) would inquire about enrollment in a drawing class ("do you use live models?") They'd tap your phone or snap your picture at a protest march against the House Committee on Un-American Activities, or a demonstration for peace, at an art opening, or coming out of your studio. But, more often, their paid "Special Informants (SI)," or their "Special Employees (SE)" were a model or two who posed for me privately or for my class, a student who joined us for beer and pizza after class, a close neighbor whose children played with ours, a fledgling artist who you helped get into an exhibition, a comrade in a meeting, an asshole buddy you trusted with your heart and being, a confidant whose life's torments were deeply intertwined with your own, the trusted friend who sat next to you at a funeral (whose sketch of me showed up in my files,) or a lover or two. Their informer's weekly reports said that I was the "leader of the youth division of the American Youth For Democracy," the "chairperson" of its art club while a design student at Art Center School in LA (Oct 44-Nov 45), that I worked as a set illustrator on a Tarzan movie, was arrested for picketing and jailed, with 800 others, during the Hollywood strike of 1946-47, and that I applied for membership in the Communist Party (2-11-48). They trailed me to Salt Lake City, queried my students about what I lectured on, described the mural I did for the Mine, Mill and Smelters Union in Bingham Canyon, and helped get me fired in the fall of 1949. They knew what papers and magazines I subscribed to, that I was a charter member of former Vice President Henry Wallace's Independent Progress Party in Utah, that I returned to LA in June of 1950 where I taught at the University of Southern California. Someone reported that I was a member of the Hollywood Arts, Sciences and Professions (11-29-50), someone reported the cars I drove, when, and at what hospital, my children were born, that I earned my living as a "commercial artist," an art teacher, a film strip artist, as the "art editor for Frontier, a magazine unfavorable to the FBI," as a lunch truck driver, an exhibiting artist, the director of an art school that (horrors!) "showed a Czech film." They even tailed me when I juried an art exhibition with Edward G. Robinson. Who knows what they had on him to make him turn informer during the blacklist? One informer said that I "must be a Communist" because I "dressed like a Communist," "only wears rolled up blue jeans, with paint spatters, a T shirt and an old jean jacket."

My studio was broken into on August 6, 1956. An informer, later exposed, who frequented my studio, guided the FBI to the portfolios and paintings I was doing on the Rosenberg's. They robbed me of art supplies, a cheap radio and over 200 works. They left me my books. Interestingly enough, pages dated three months prior to, and three months after the robbery, were deleted from the over 760 file pages sent me.

Not that the remaining pages themselves were so all revealing—they come to you with all the pertinent information—the informer's names, who those close comrades actually were, who you were in bed with, all black markered out. What intrigued me the most, aside from the nostalgia they obviously generated, was how the sheer aesthetic beauty of the pages themselves, the bold, black, slashing strokes looked like Franz Kline color sketches, with typewriter words peeking through.

I have integrated some of them, together with recent paintings, drawings and other images about those times, into contemporary Illuminated Manuscripts, works on paper and canvas.

Arnold Mesches November 1, 2001 New York City

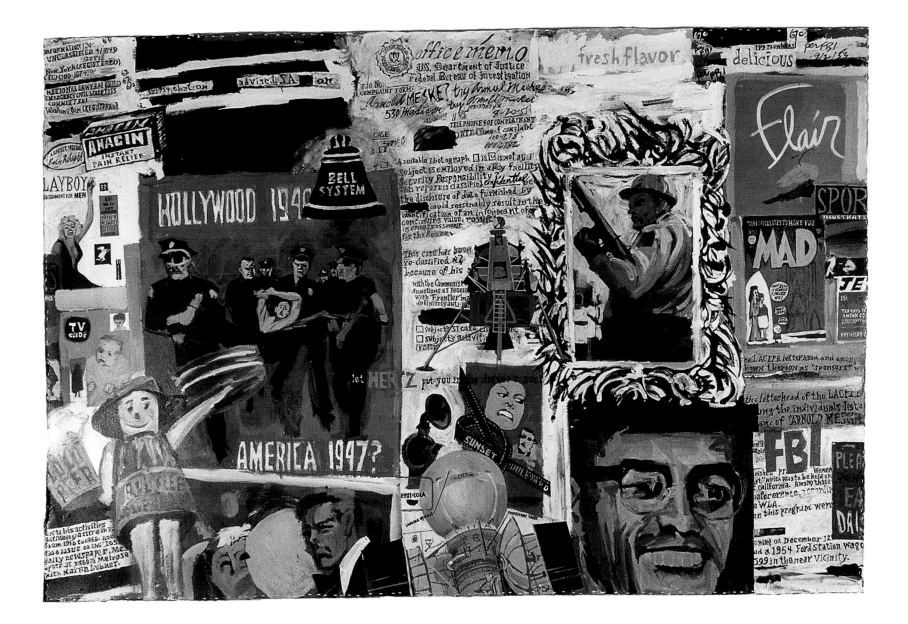

SURVEILLANCE, 84" x 126", acrylic on canvas, 2000

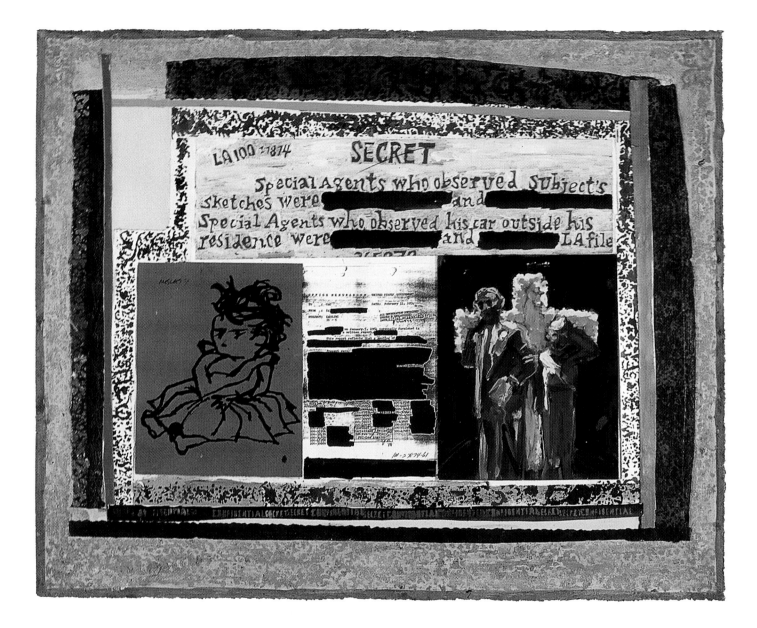

1. 30 3/4" x 38 1/2", mixed media collage on paper, 2001

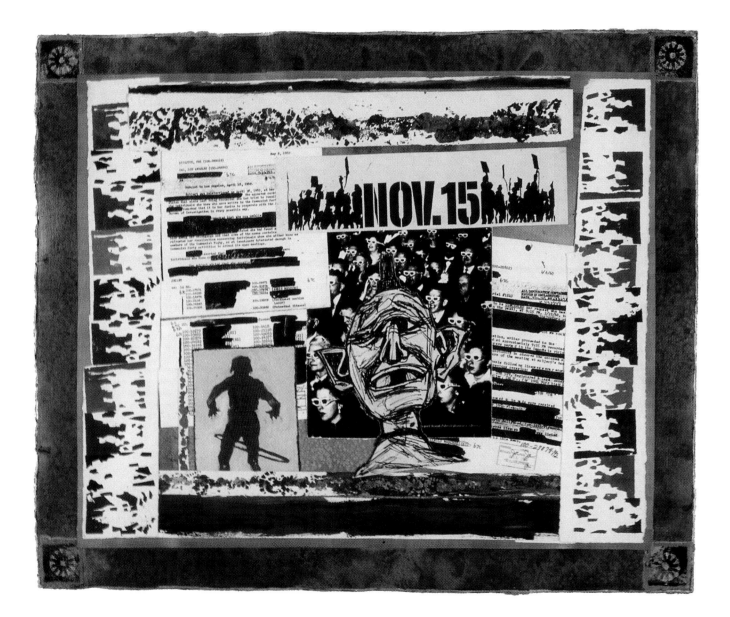

2. 25 7/8" x 31 5/8", mixed media collage on paper, 2001

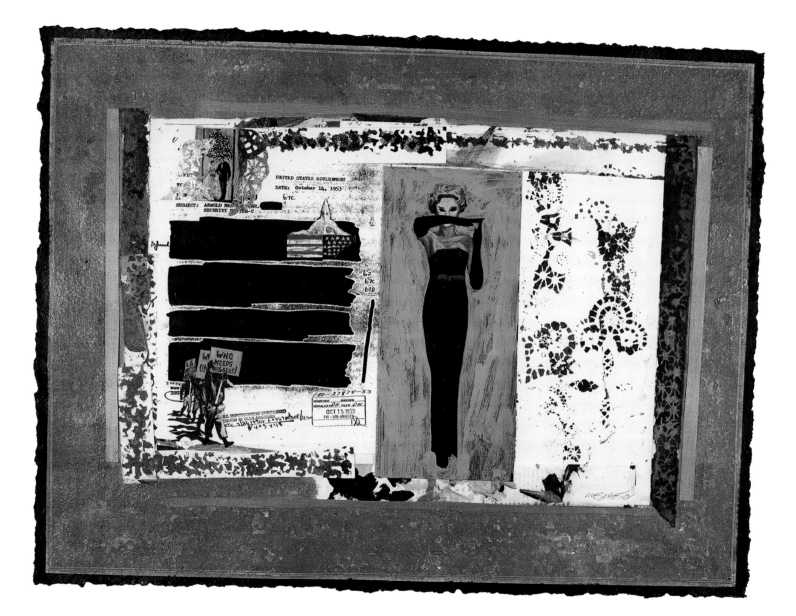

3. 18 1/8" x 24 5/8", mixed media collage on paper, 2001

Collection : John McCall, Austin, Texas

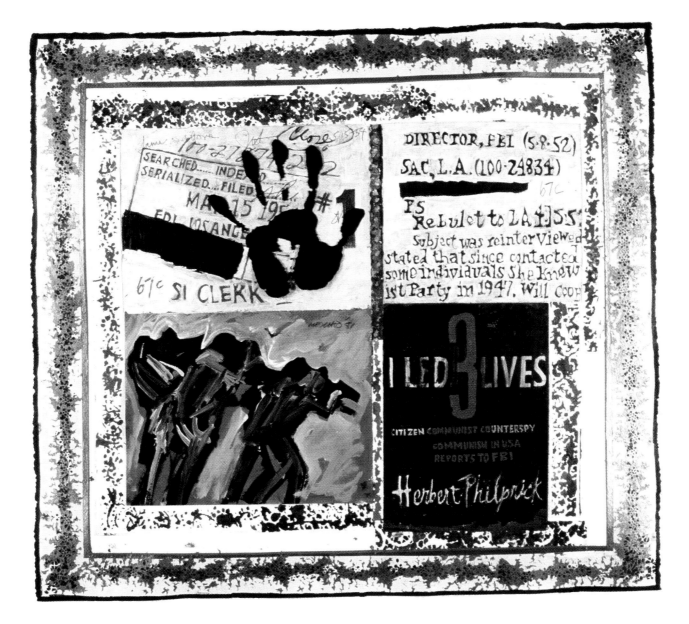

4. 27 3/4" x 30 3/4", mixed media collage on paper, 2001

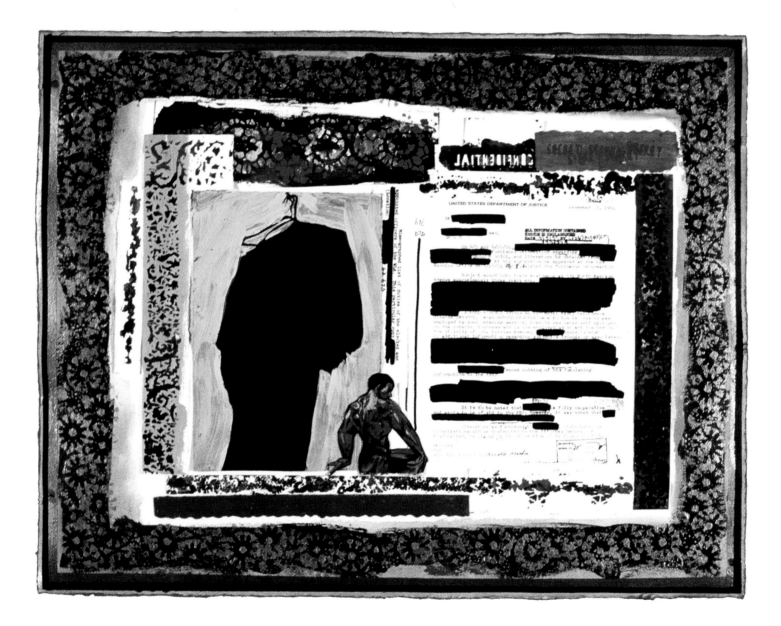

5. 20 1/8" x 26", mixed media collage on paper, 2001

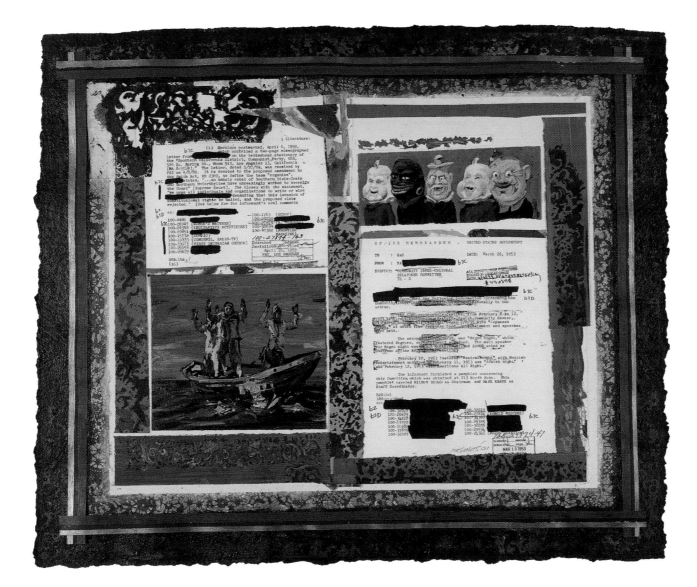

6. 22 1/2" x 27 3/8", mixed media collage on paper, 2001

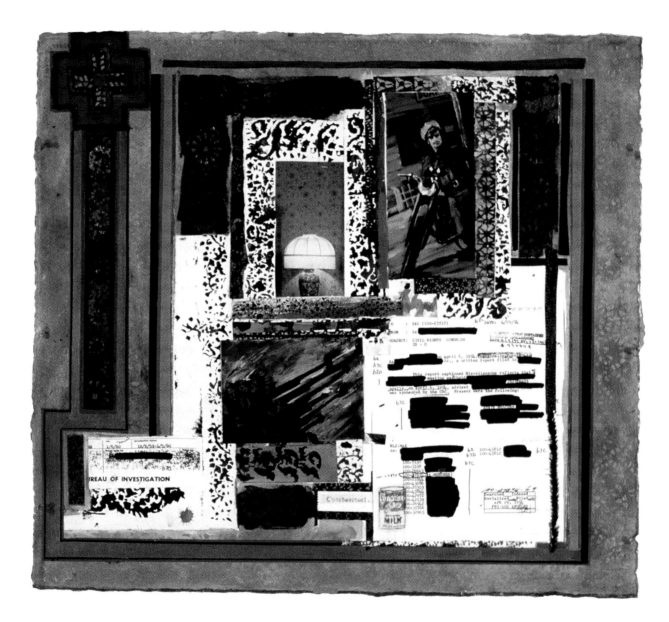

7. 22" 3/4 x 25 3/8", mixed media collage on paper, 2001

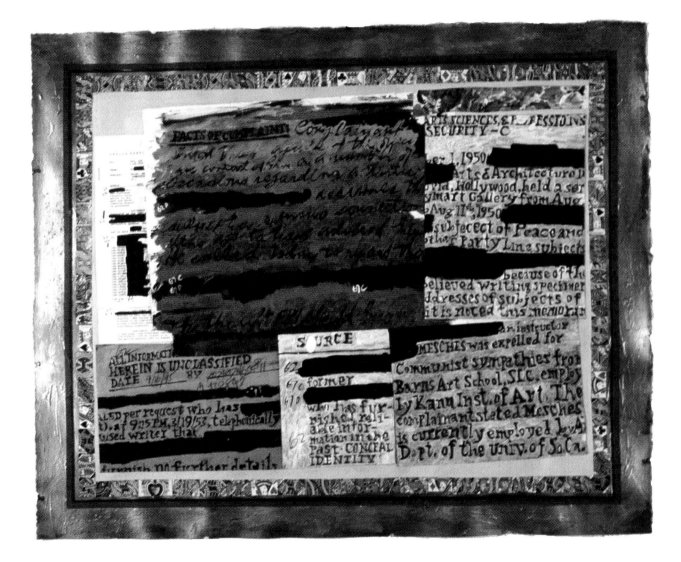

8. 32 1/2" x 39 1/8", acrylic on board and paper on paper, 2001

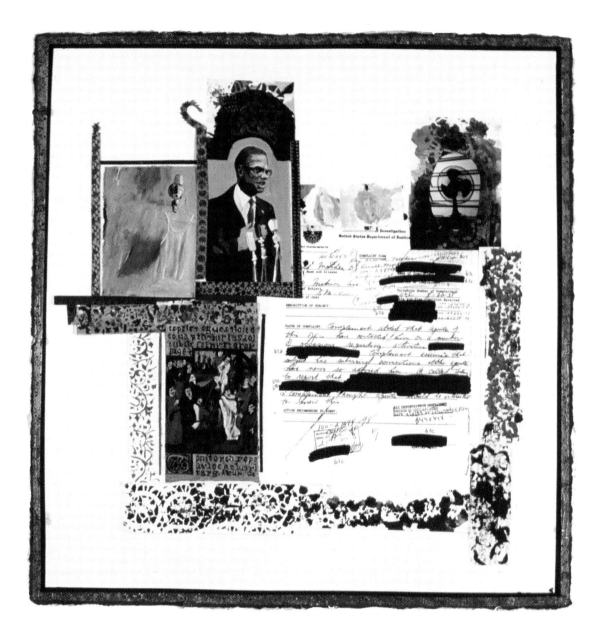

9. 22 3/4" x 22 3/8", mixed media collage on paper, 2001

Collection: Geri and Charles Lemert, Killingworth, Connecticut

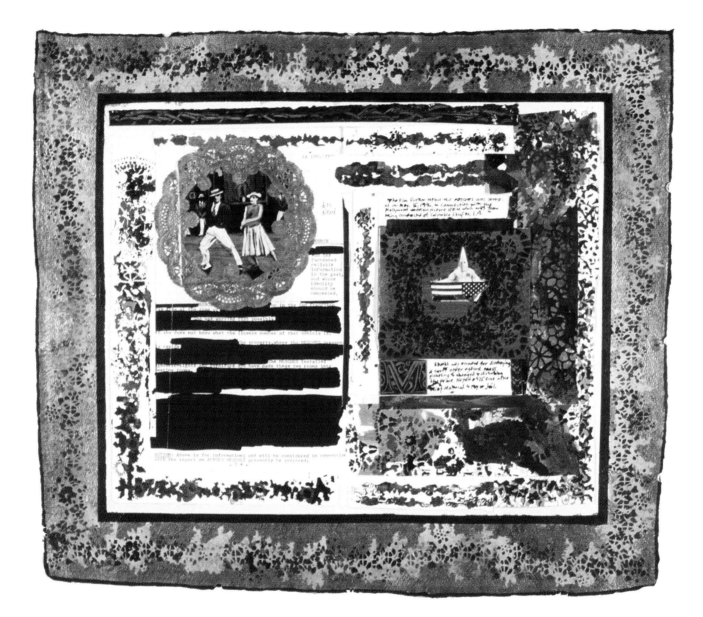

10. 20" x 23 1/2", mixed media collage on paper, 2001

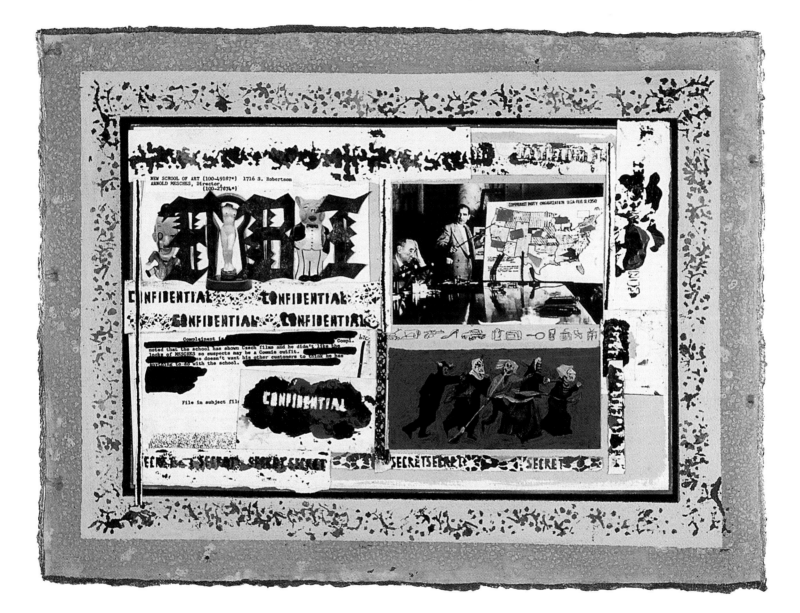

11. 19 1/8" x 25 7/16", mixed media collage on paper, 2001

Collection: Jim and Sak Costanzo, New York, New York

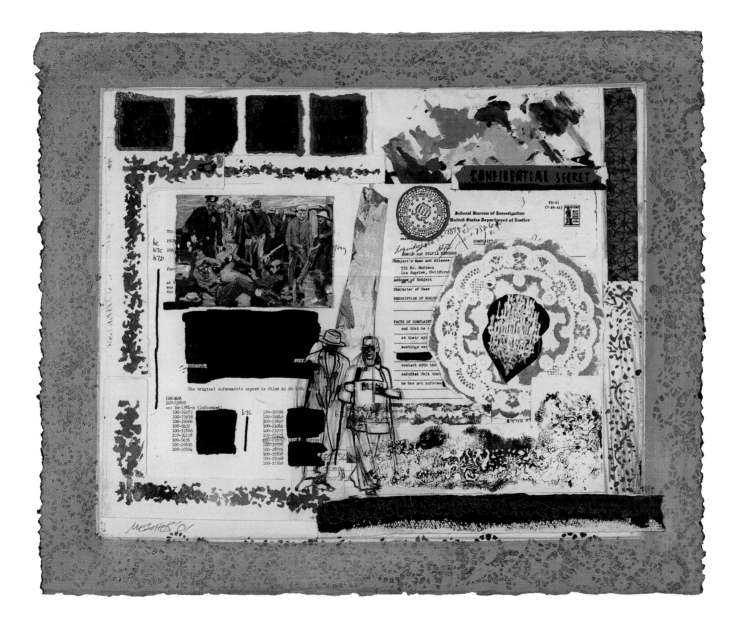

12. 20 3/8" x 24 3/4", mixed media collage on paper, 2001

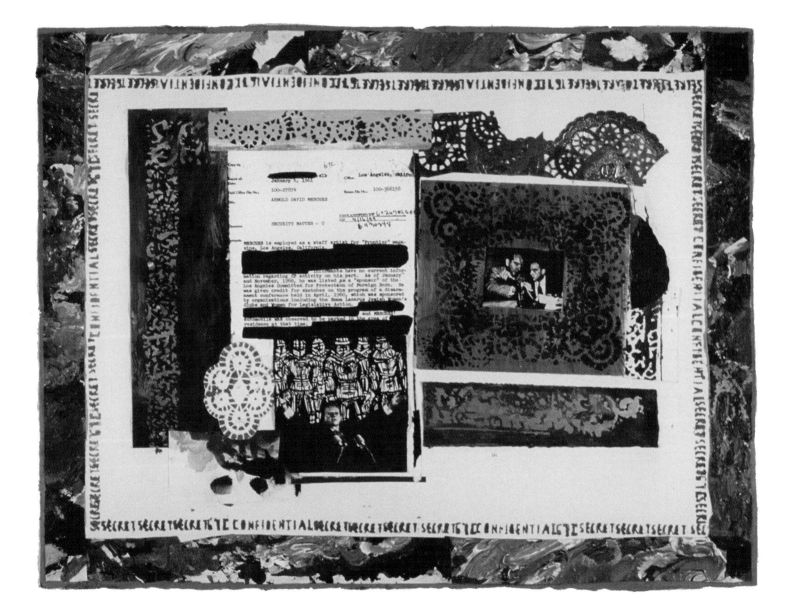

13. 19 3/4" x 26", mixed media collage on paper, 2001

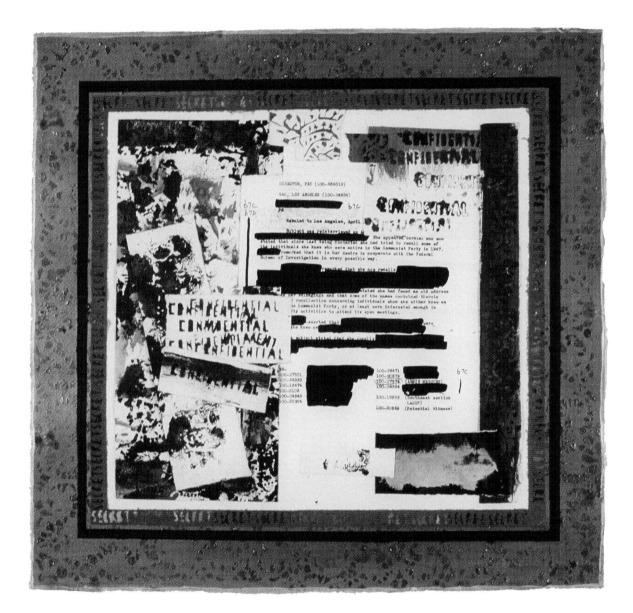

14. 17 5/8" x 18 3/4", mixed media collage on paper, 2001

Collection: Charlotta and Peter Kotik, Brooklyn, New York

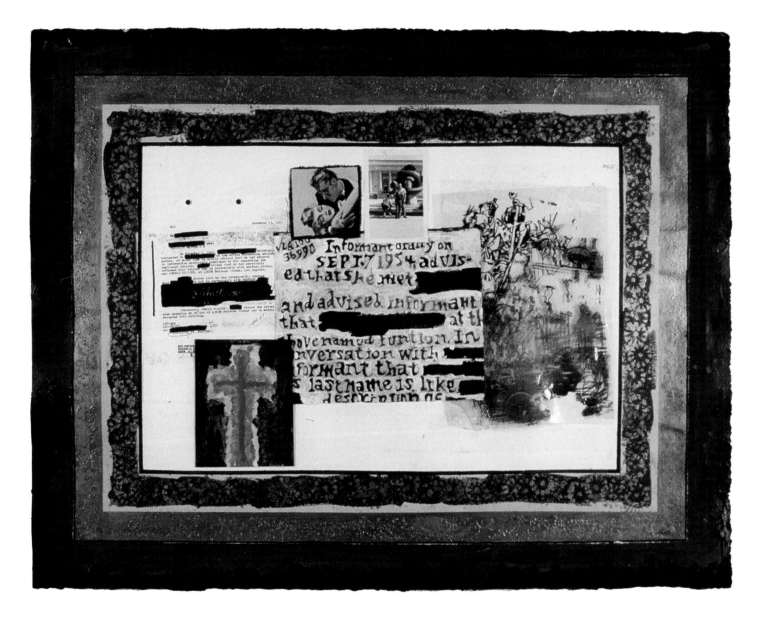

15. 30" x 38 3/4", mixed media collage on paper, 2001

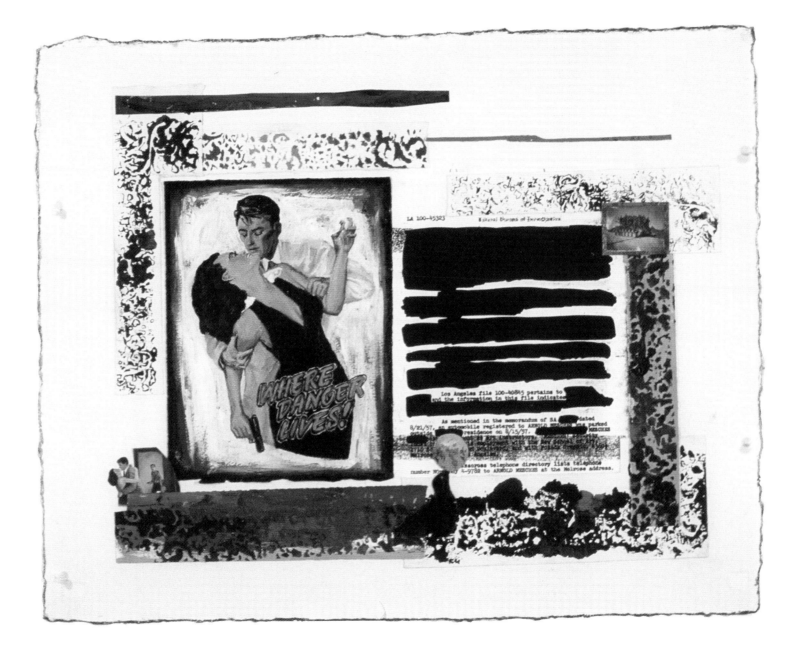

16. 17 3/4" x 22 3/4", mixed media collage on paper, 2001

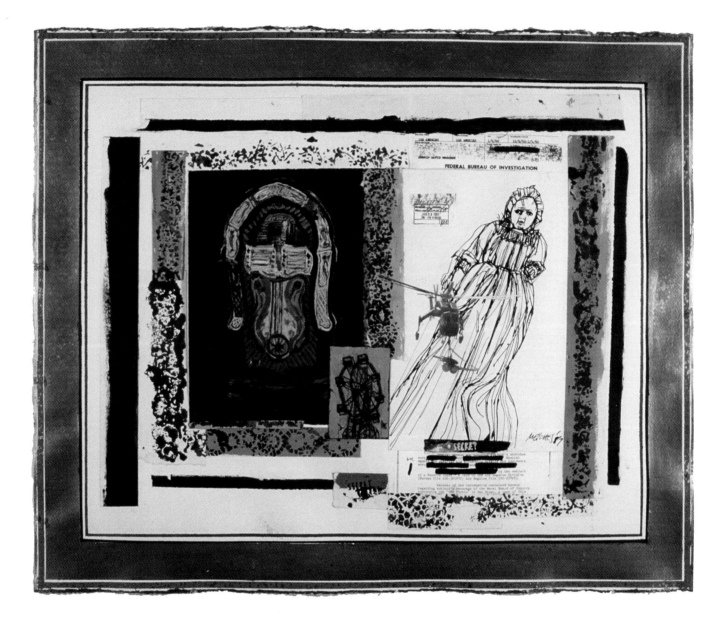

17. 25 1/4" x 35 3/8", mixed media collage on paper, 2001

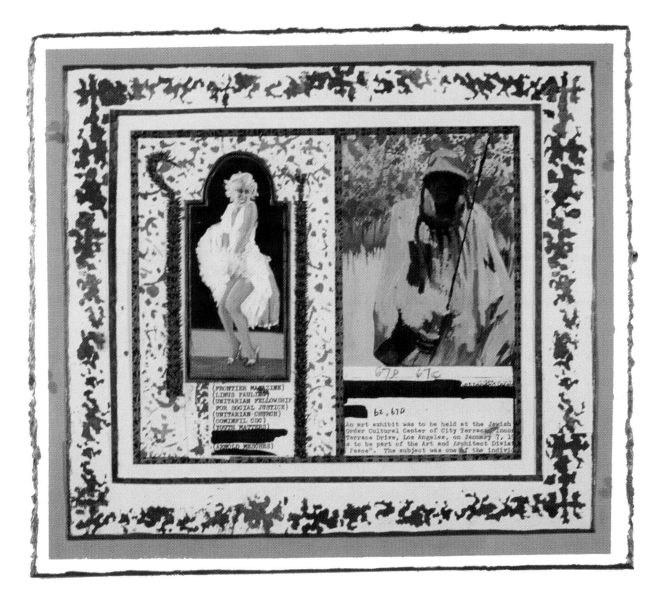

18. 13 7/8" x 16", mixed media collage on paper, 2001

Collection: Meg Cox and Richard Leone, Princeton, New Jersey

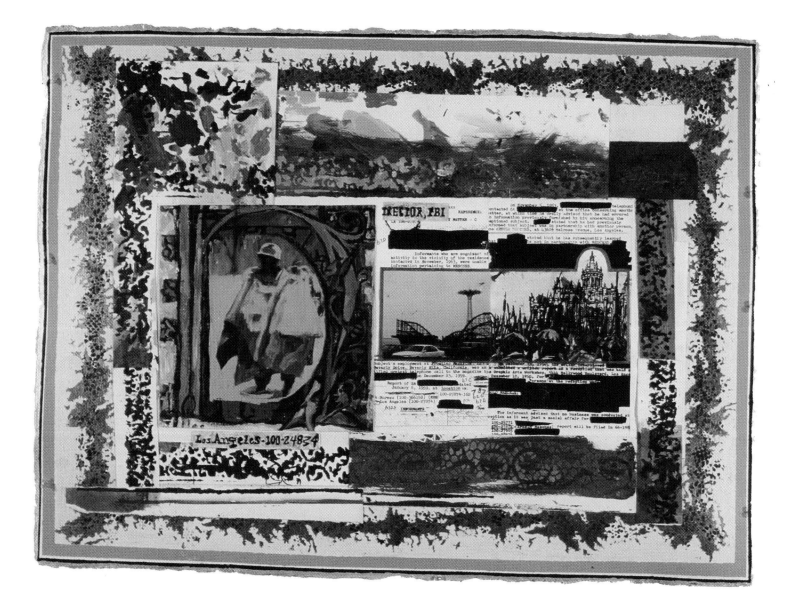

19. 22 3/4" x 30 1/4", mixed media collage on paper, 2001

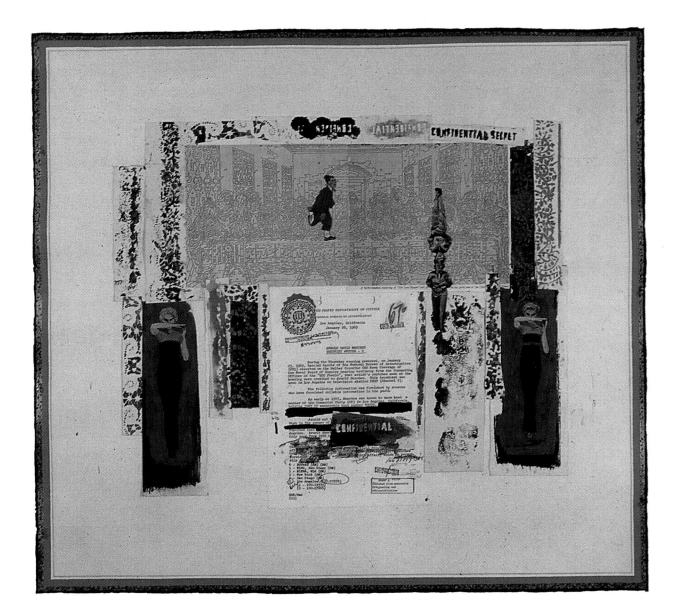

20. 28 5/8" x 32 1/8", mixed media collage on paper, 2001

Collection: Jill Ciment, Gainseville, Florida

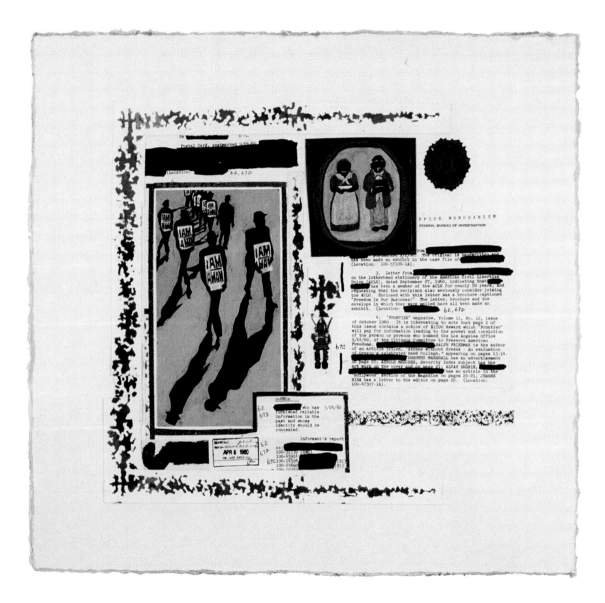

21. 20 5/8" x 22 7/8", mixed media collage on paper, 2001

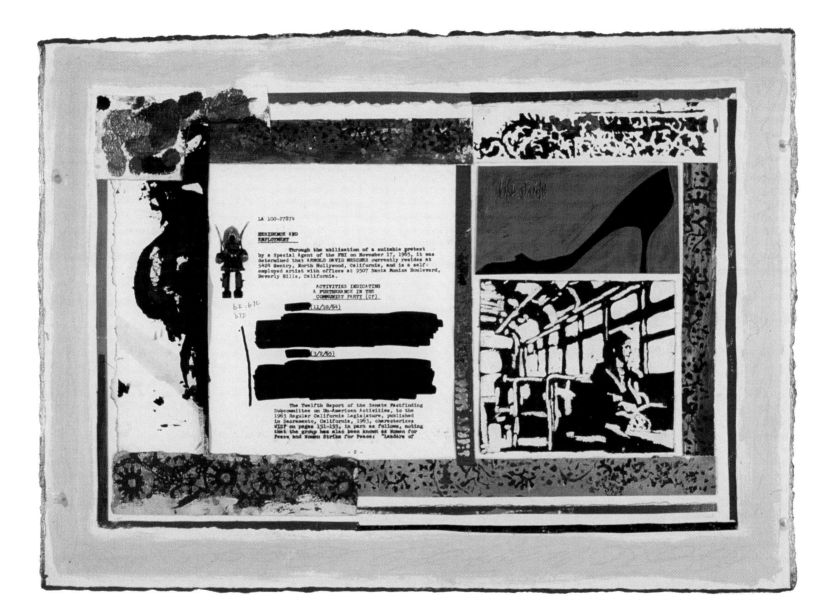

22. 18" x 25 1/4" acrylic on canvas and illustration board on paper, 2001

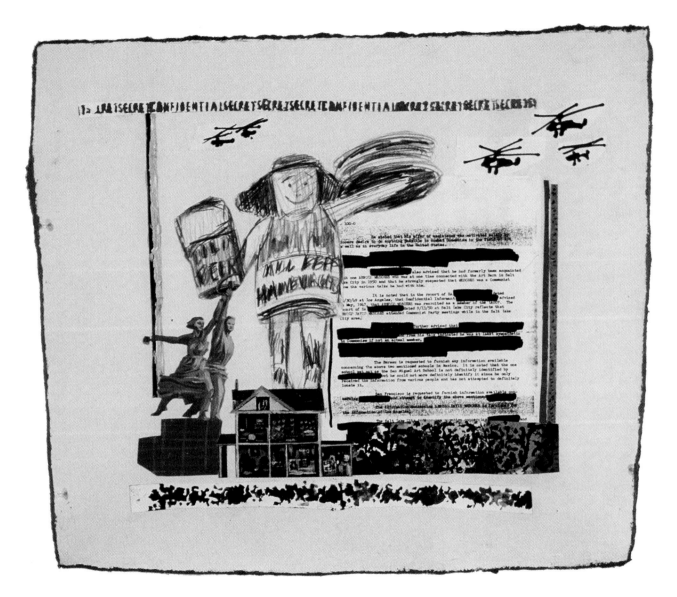

23. 20 1/4" x 23 1/2", acrylic and pencil on paper, 2001

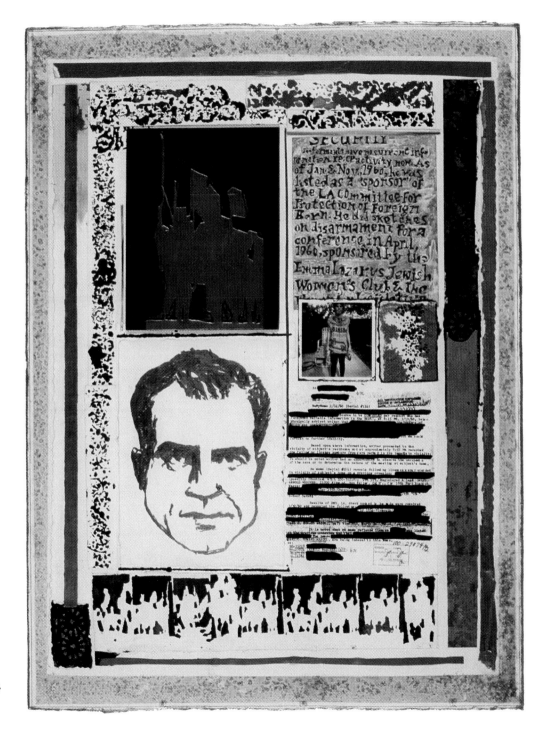

24. 34 1/8" x 26 1/8", acrylic/photo/linoleum on paper, 2001

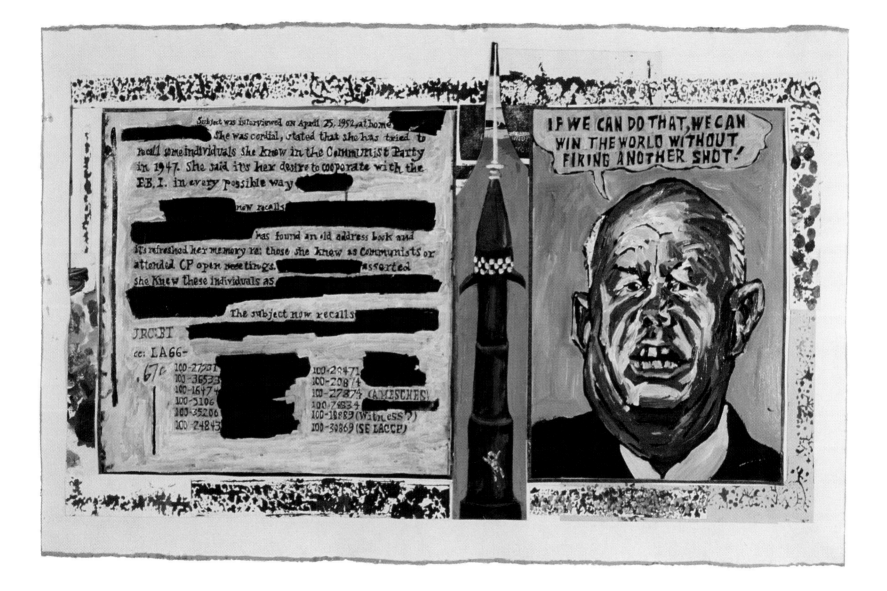

25. 24 1/2" x 43 3/4", acrylic on paper and illustration board on paper, 2001

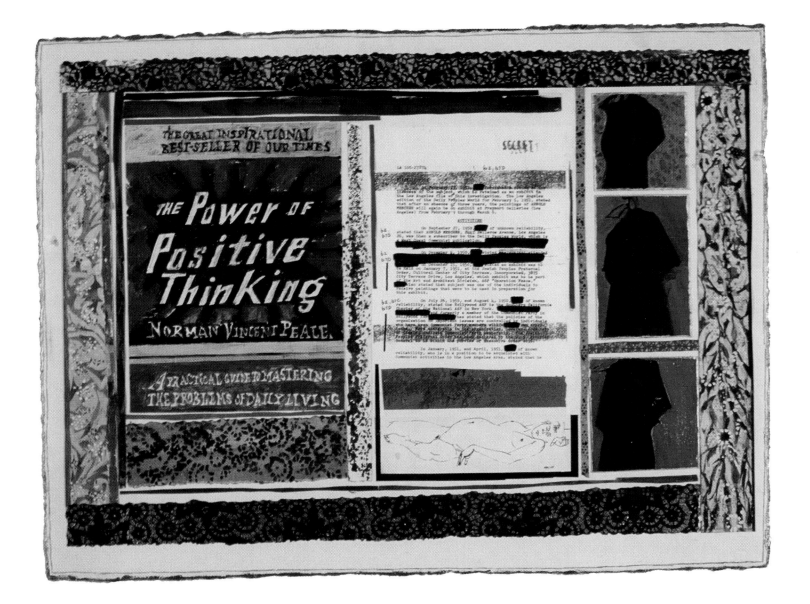

26. 23" x 30 1/2", acrylic on paper and illustration board on paper, 2001

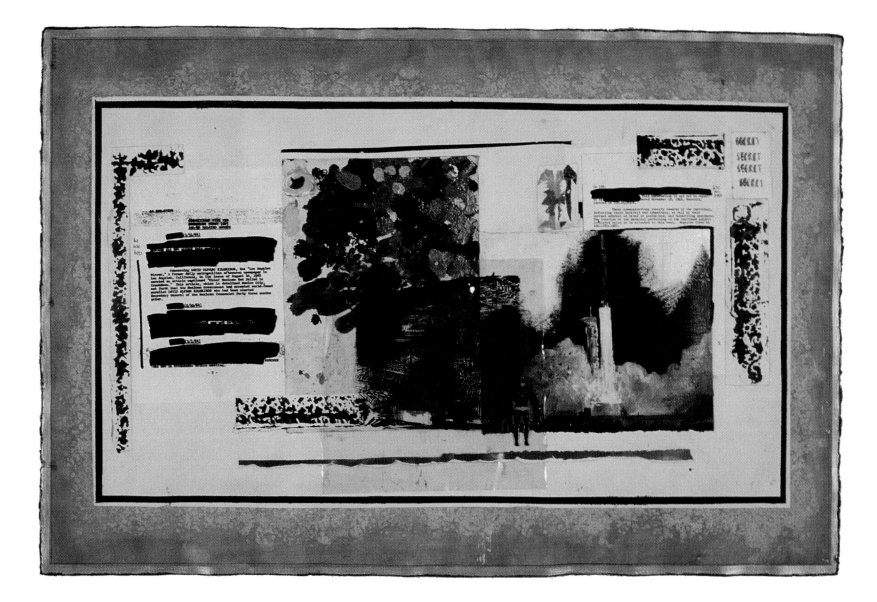

27. 26 "x 41", mixed media collage on paper, 2001

Collection: Willow Johnson and Patrick Pexton, Washington, District of Columbia

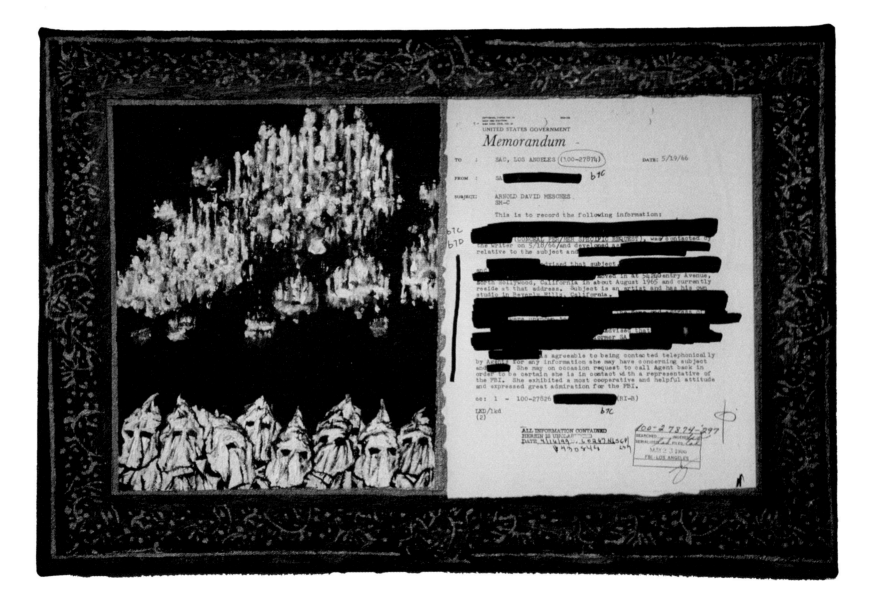

28. 15" x 21 1/4" acrylic and paper on canvas, 2002

Collection: John McCall, Austin, Texas

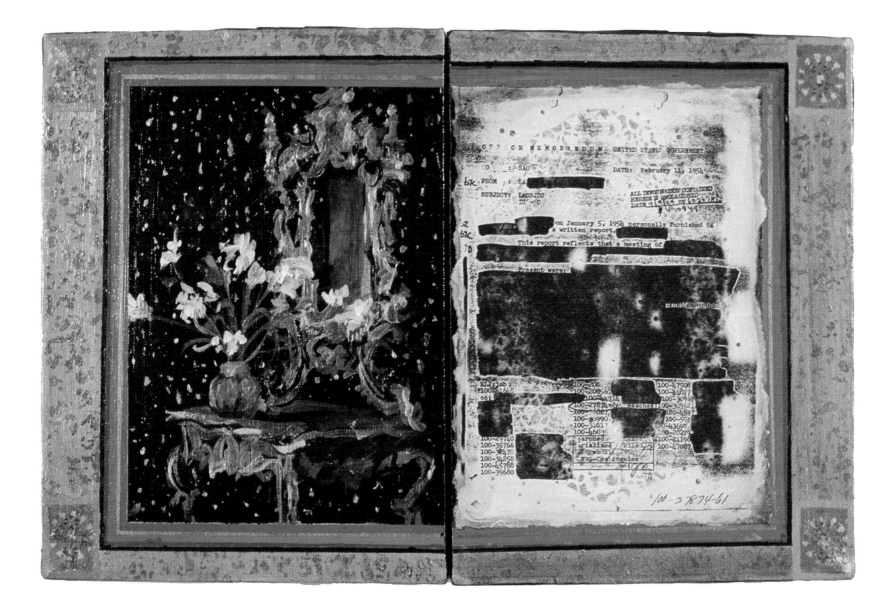

29. 14" x 22", acrylic and paper on canvas, 2002

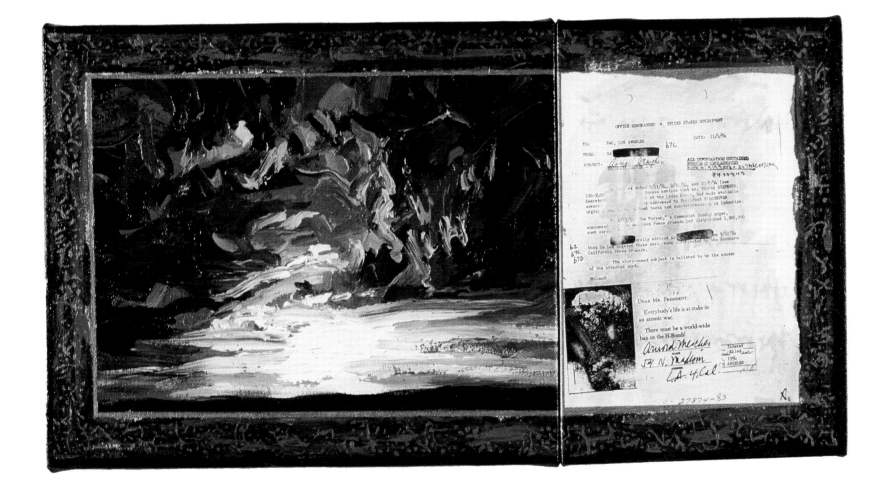

30. 14 5/8" x 28 3/4", acrylic and paper on canvas, 2002

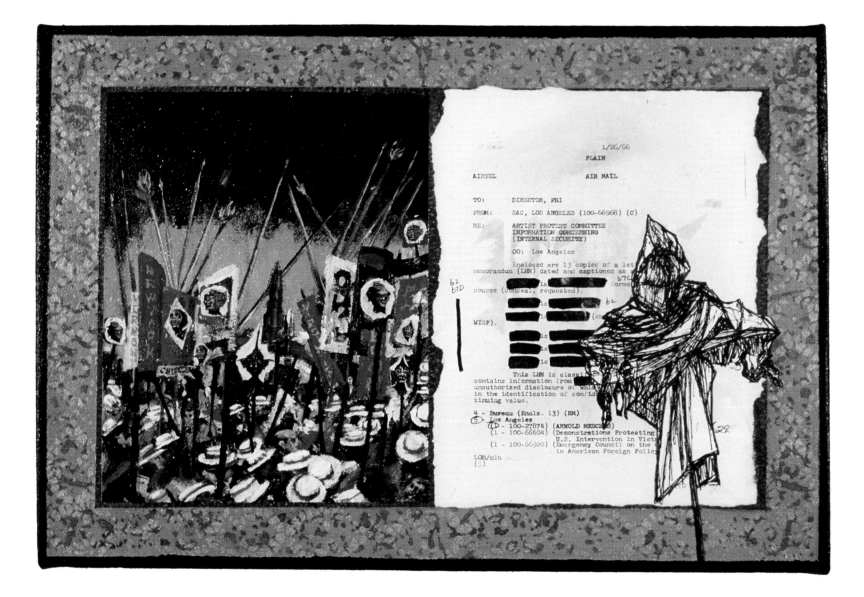

31. 14 3/4" x 20 3/4", acrylic and paper on canvas, 2002

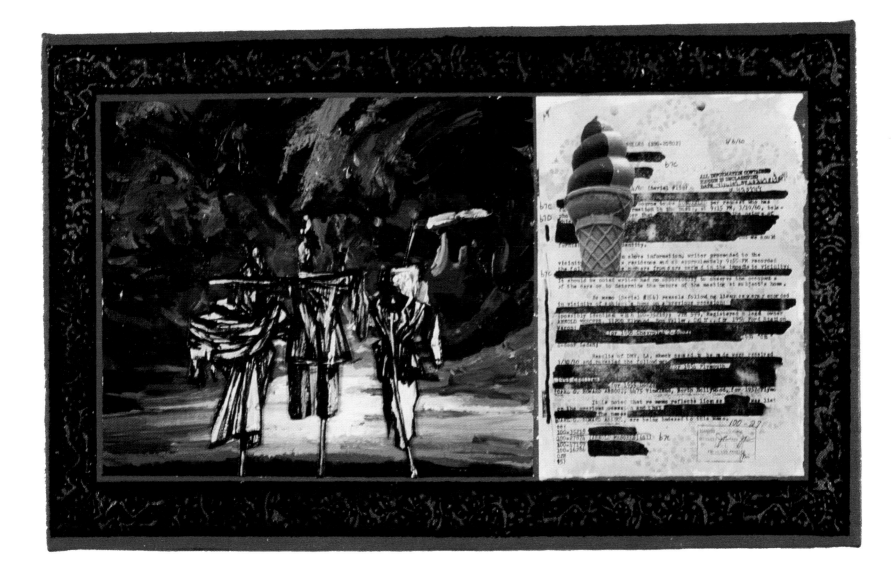

32. 15 3/8" x 26 3/8", acrylic and paper on canvas, 2002

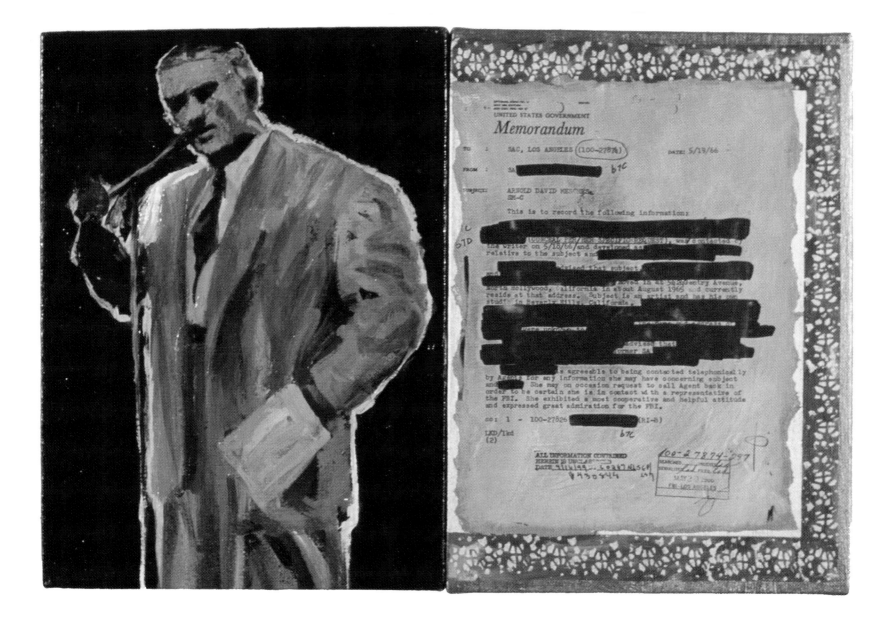

33. 14" x 20 1/4", acrylic and paper on canvas, 2002

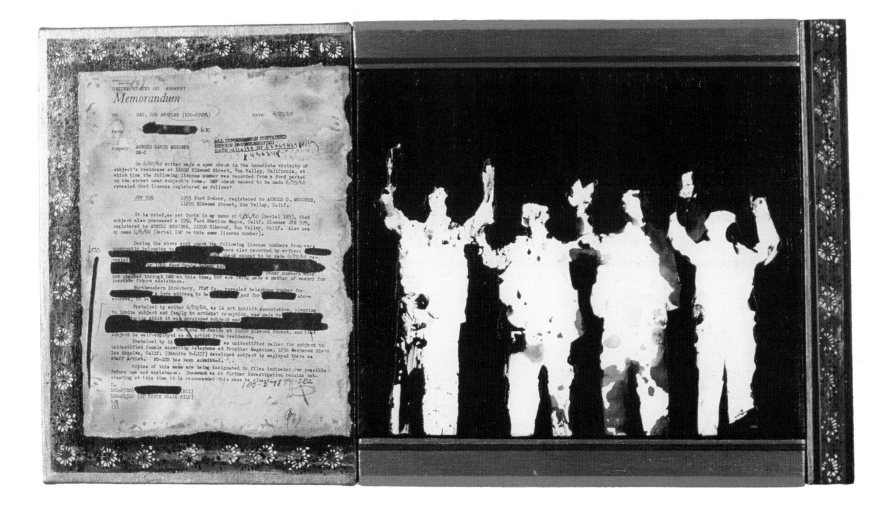

34. 14" x 15 5/8", acrylic and paper on canvas and wood, 2002

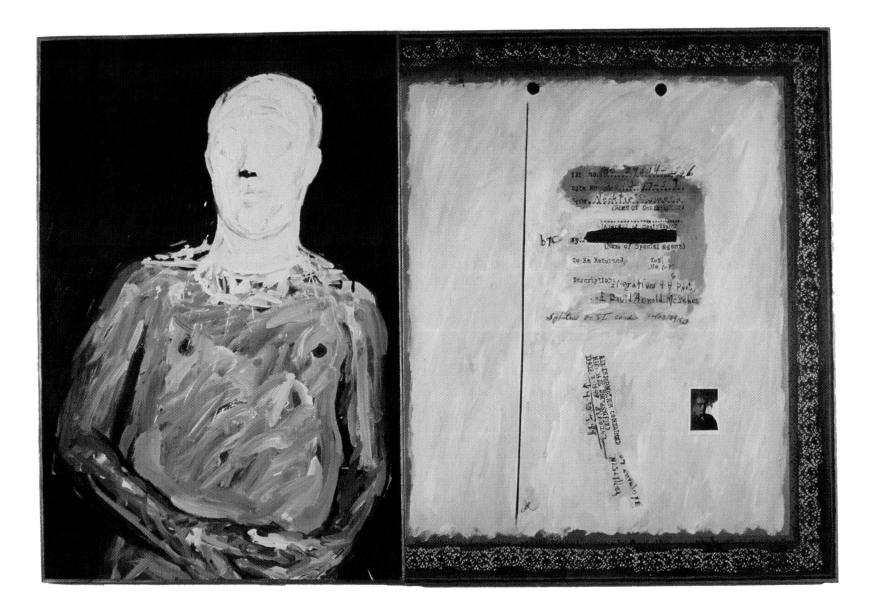

35. 60" x 87", acrylic and paper on canvas, 2002

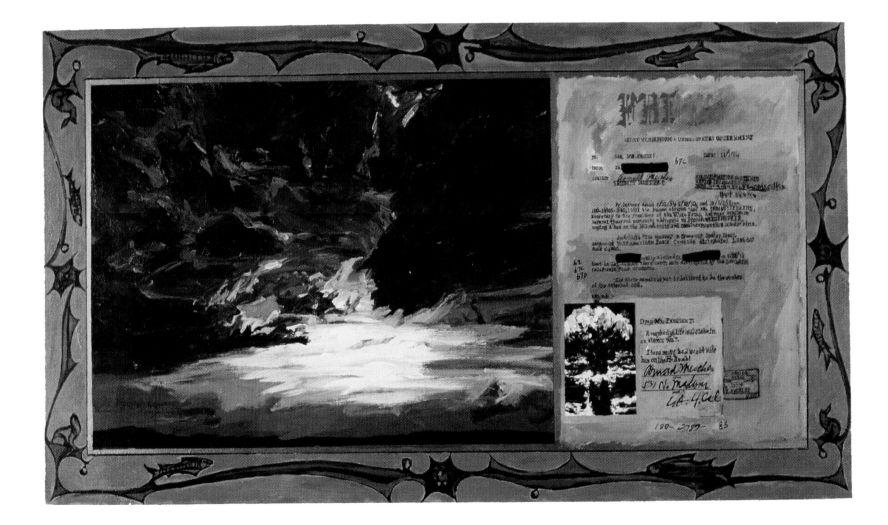

36. 42" x 80" acrylic on canvas, 2002

Collection of Joann Shapiro, Chicago, Illinois

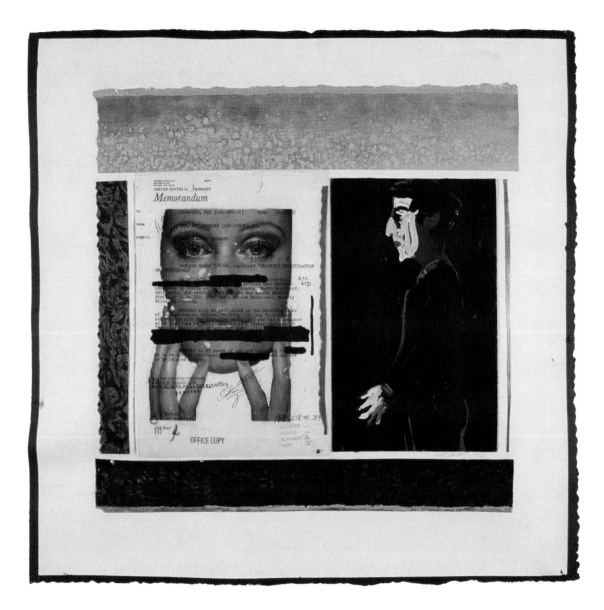

37. 21 5/8" x 23 1/4", acrylic on illustration board and paper, acetate on paper, 2002

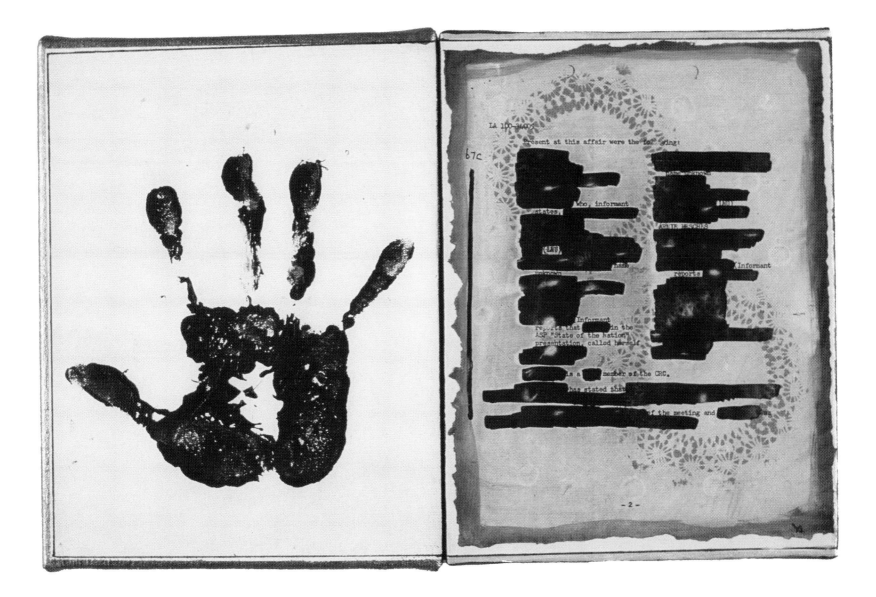

38. 12" x 18", acrylic and paper on canvas, 2002

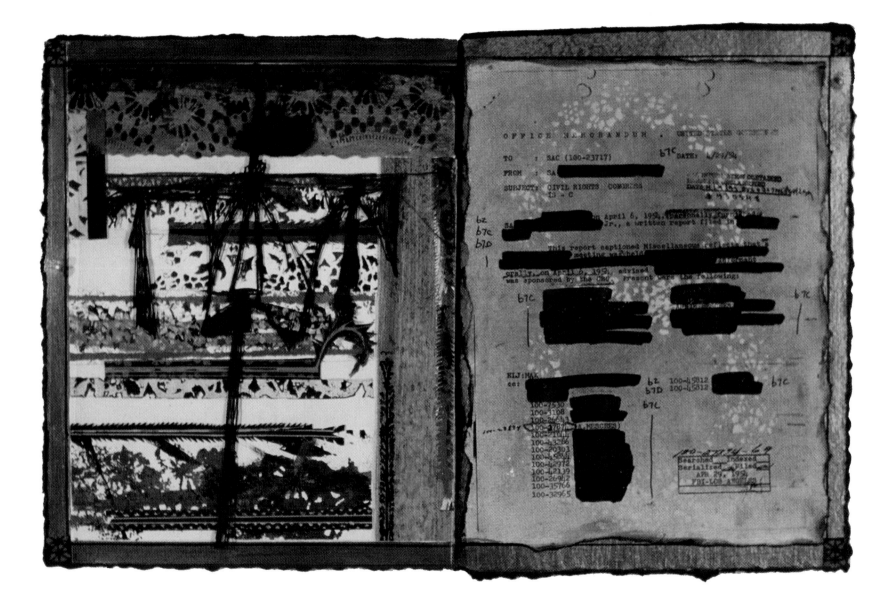

39. 12 7/8" x 18 7/8", acrylic on paper, acetate on paper, 2002

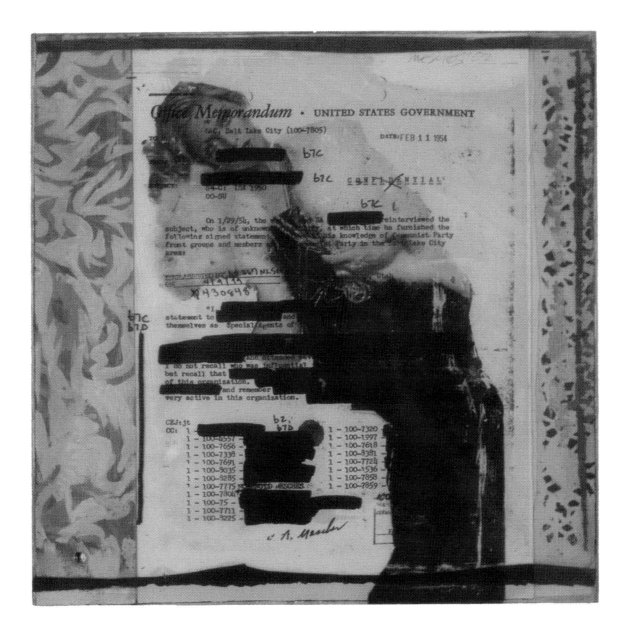

40. 12" x 12", acrylic on paper, transfer on plexiglas on canvas, 2002

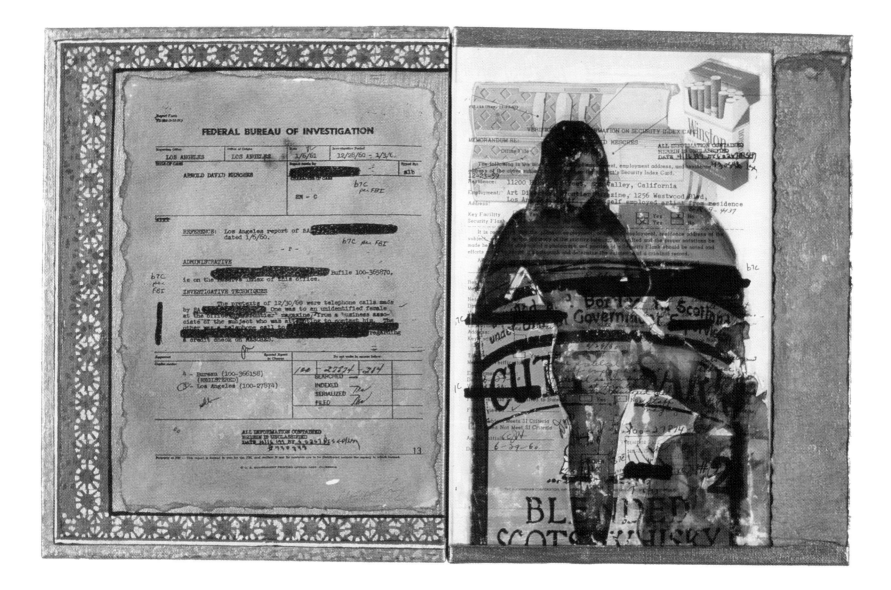

41. 14" x 22", acrylic on paper, transfer on plexiglas on canvas, 2002

42. 14" x 20", pen and ink, transfer on illustration board, acrylic on paper on canvas, 2002

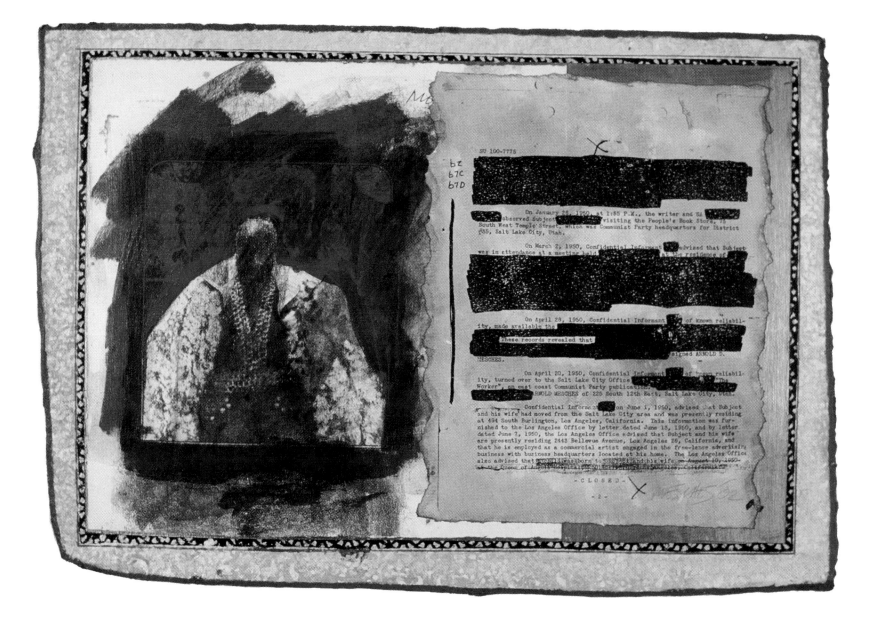

43. 14 1/4" x 20", transfer and acrylic on illustration board on paper, 2002

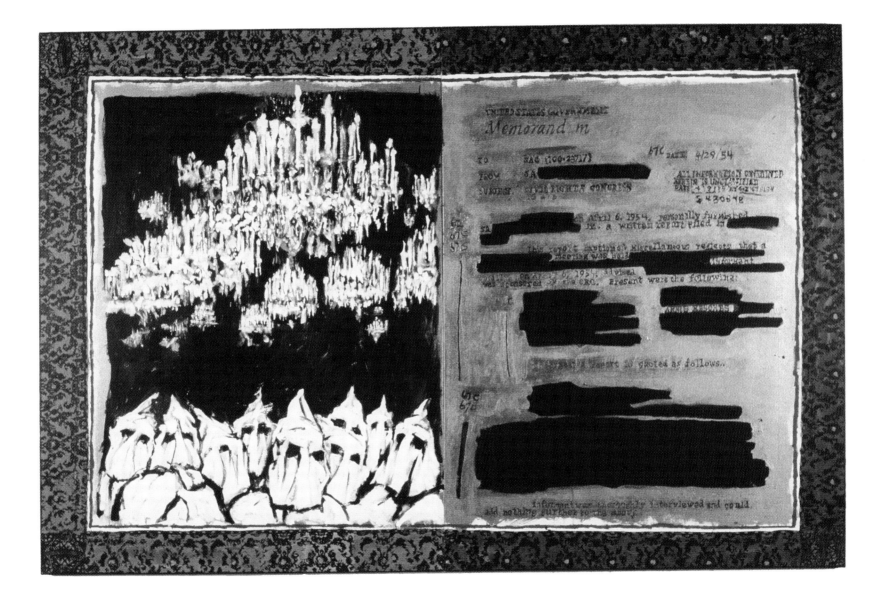

44. 60" x 84", acrylic on canvas, 2002

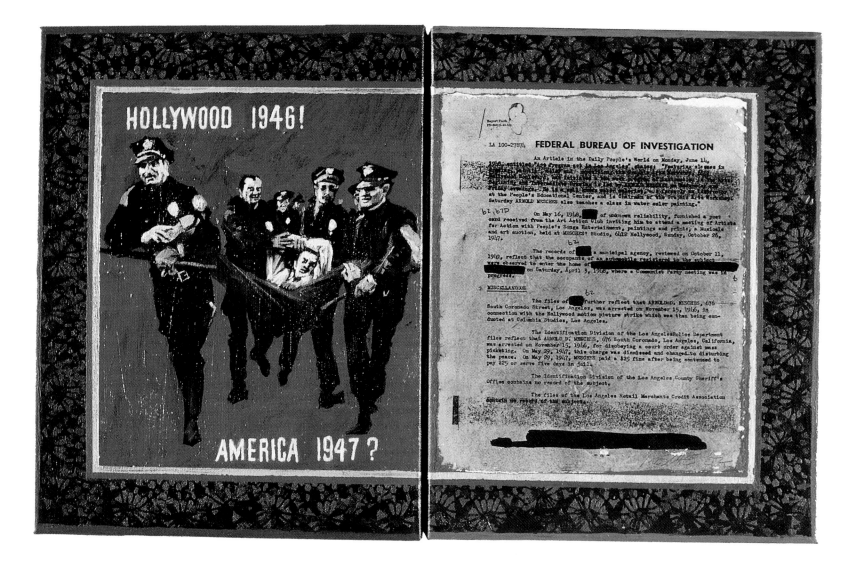

45. 14" x 22", acrylic on paper and canvas, 2002

46. 12" x 18", acrylic on paper and Polaroids on canvas, 2002

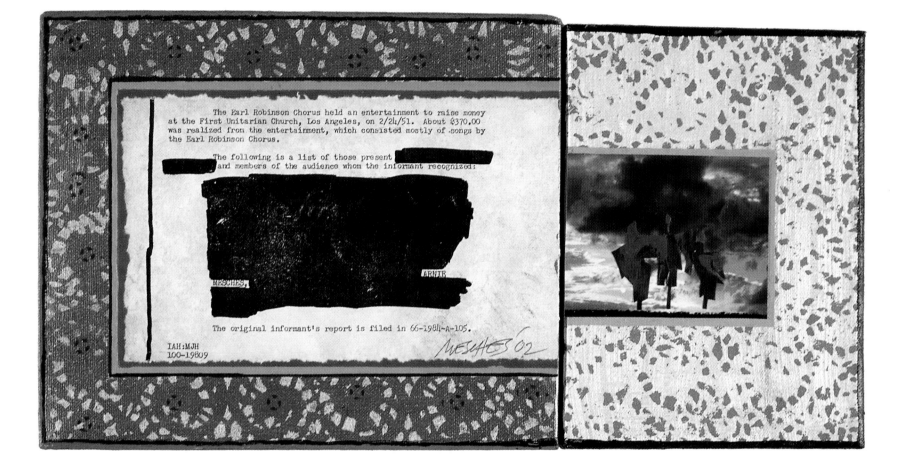

The Earl Robinson Chorus held an entertainment to raise money
at the First Unitarian Church, Los Angeles, on 2/24/51. About $370.00
was realized from the entertainment, which consisted mostly of songs by
the Earl Robinson Chorus.

The following is a list of those present ████████
████████ and members of the audience whom the informant recognized:

MESCHES ARNIE

The original informant's report is filed in 66-1984-A-105.

IAH:MJH
100-19809

47. 8" x 16", acrylic on paper, Polaroid on canvas, 2002

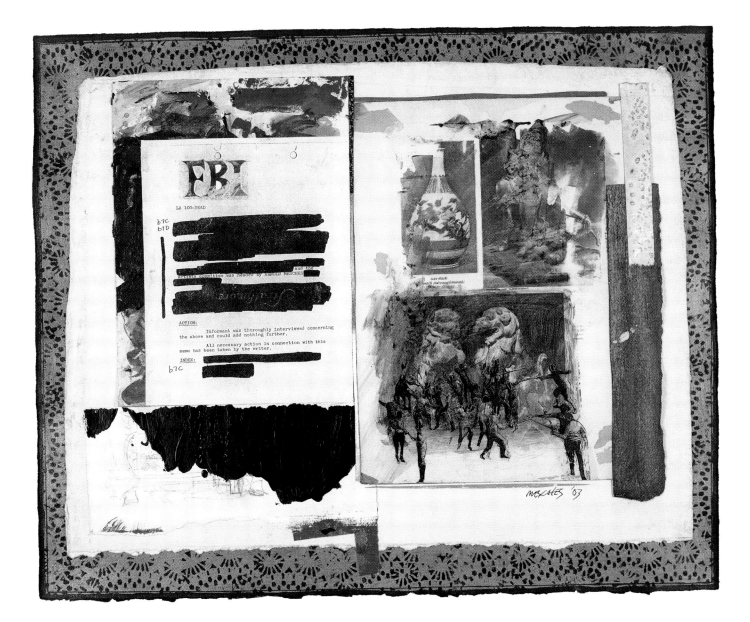

48. 20 3/4" x 25 3/4", acrylic, transfer, board on paper, 2003

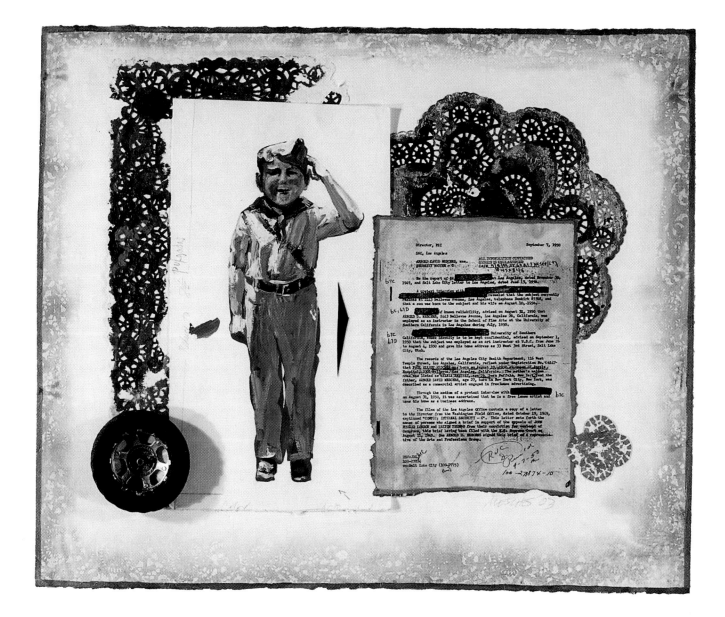

49. 22 1/8" x 27 1/8", acrylic, board, paper on paper, 2003

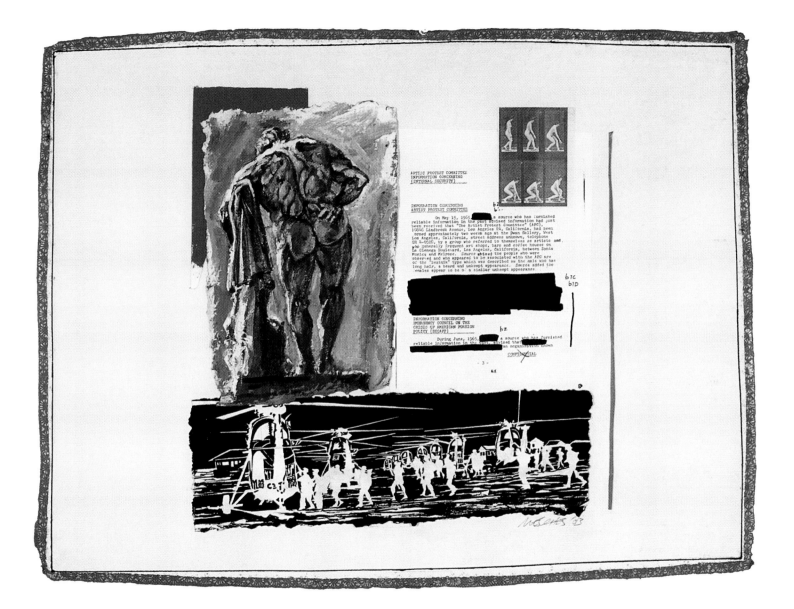

50. 23" 1/2 x 31", acrylic, ink, paper, on paper, 2003

Collection: Celeste Roberge, Gainesville, Florida

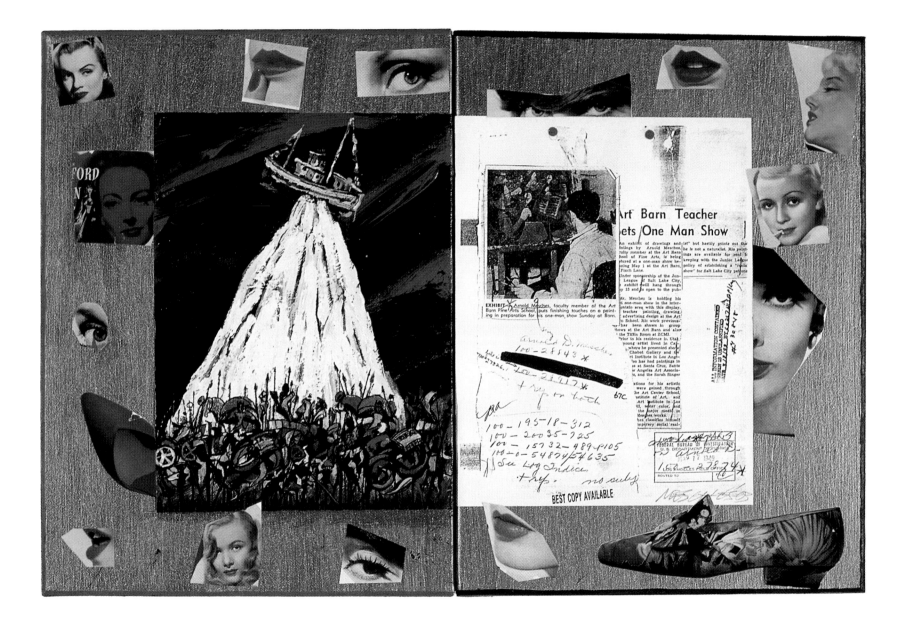

51. 16" x 24", acrylic, ink, paper on canvas, 2003

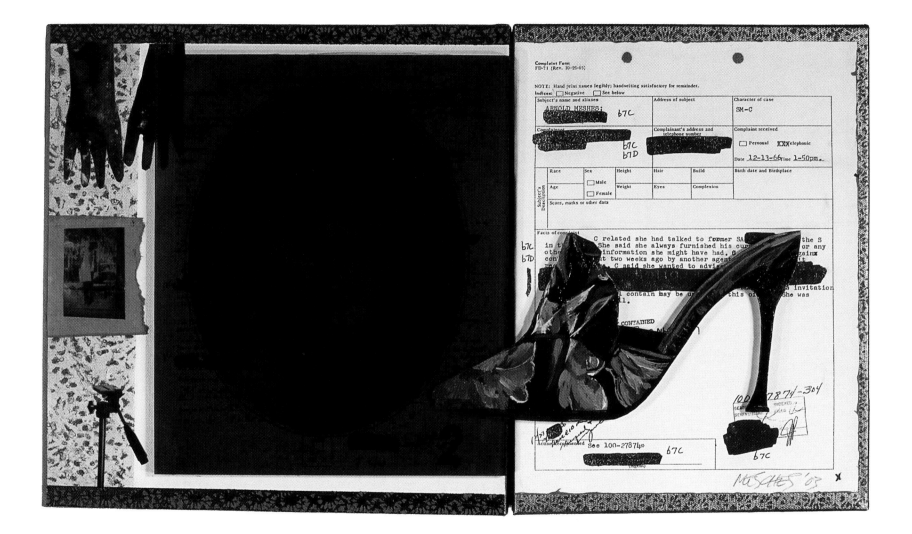

52. 12" x 21", acrylic on paper, plexi transfer, Polaroid on canvas, 2003

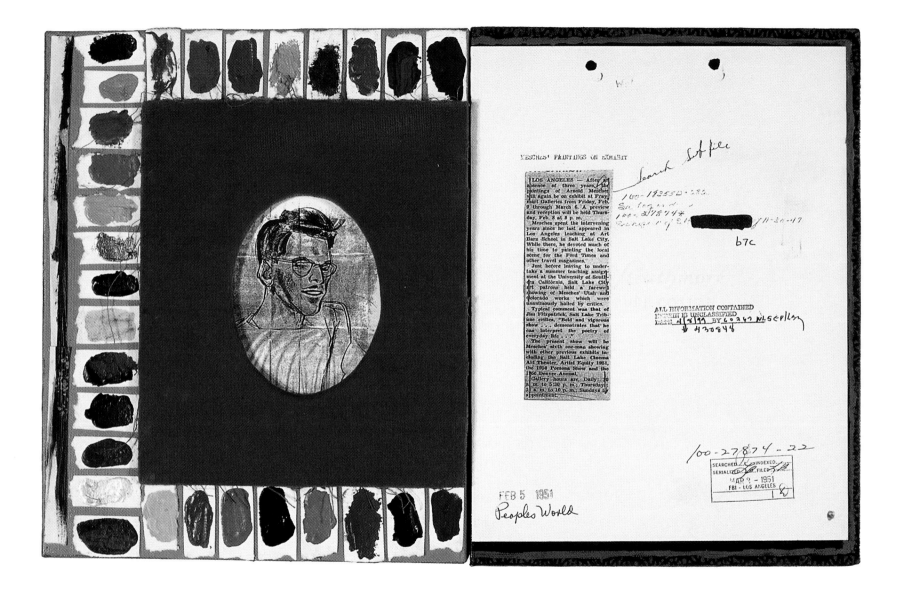

53. 12" x 19", acrylic on paper, felt on canvas, 2003

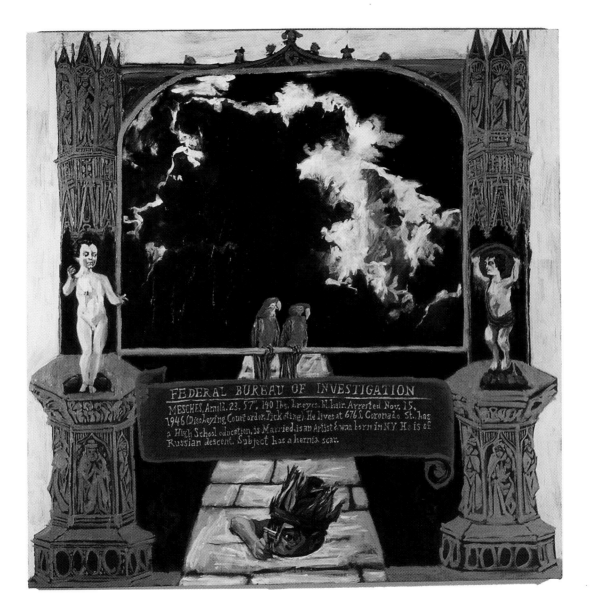

54. 80" x 80", acrylic on canvas, 2003

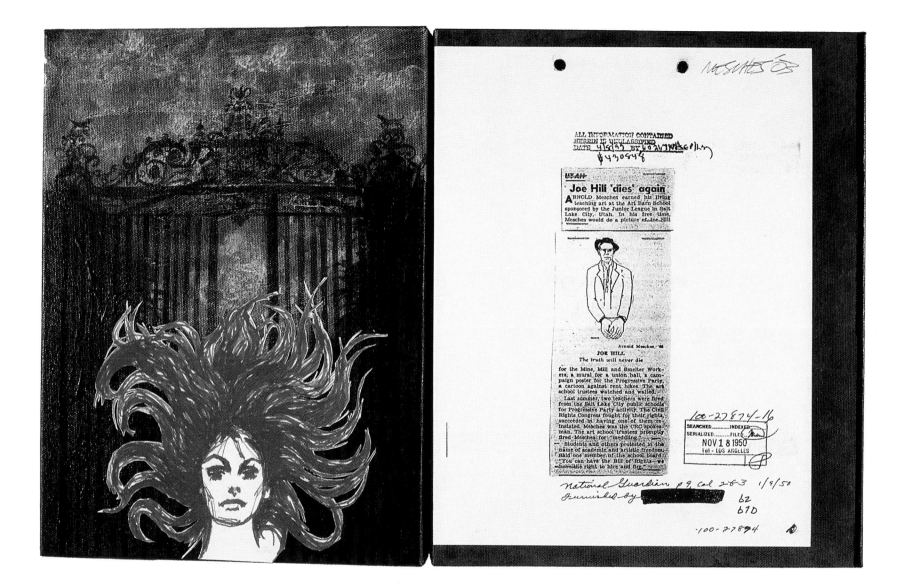

55. 12" x 19", acrylic and ink, paper on canvas, 2003

(Collection of the artist)

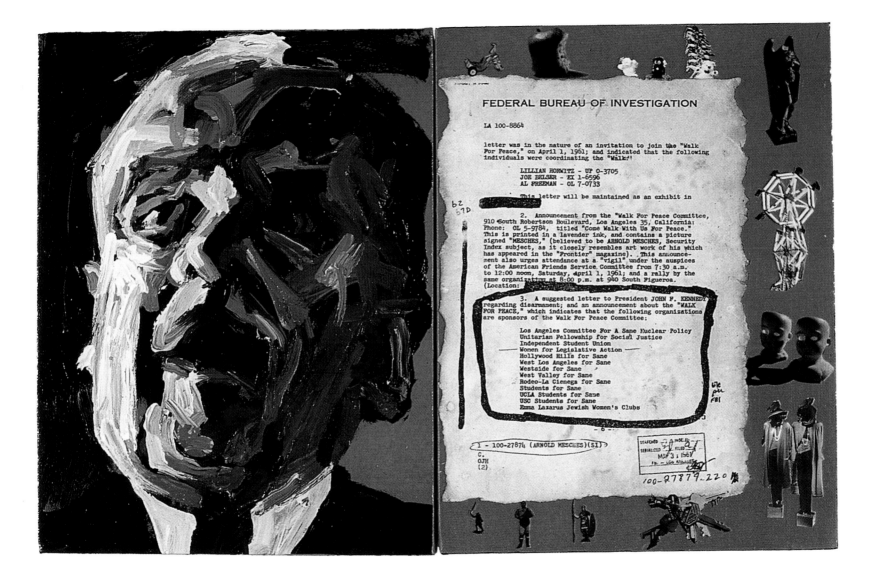

56. 14" x 22", acrylic, Polaroid, paper on canvas, 2003